Yavalath & Co.

v 1.0

Néstor Romeral Andrés

Art by

Néstor Romeral Andrés

Games designed by

Cameron Browne's LUDI
Néstor Romeral Andrés
Cameron Browne
Dieter Stein
Stephen Linhart
Vikingur Fjalar Eiríksson
Élanor Grace Rodeffer
Nick Bentley

Néstor Romeral Andrés is the owner of **nestor**games and has produced more than 200 games. He has also designed dozens of them and was the Spanish Game Designer of the Year for 2009-2010.

Text, figures, design, cover and art by Néstor Romeral Andrés.

Get your Yavalath set here: **www.nestorgames.com**

Thanks to:

My friend **Cameron Browne** for Creating LUDI, agreeing on Yavalath's publication, hiring me for the "UCT for Games and Beyond" project and tirelessly testing board games with me.

My friend **Dieter Stein** for inviting me to fine-tune Manalath.

Stephen Linhart, Vikingur Fjalar Eiríksson, Nick Bentley and Eleanor's father Clark for letting me include their games.

Yavalath & Co. v1.0
Copyright © 2014 by Néstor Romeral Andrés.
All rights reserved. Inventors retain the rights to their games.
ISBN: 978-1-312-59453-1
Lulu.com

The Yavalath set	5
Prologue by Cameron Browne	7
The set	8
The games	9
Games playable with paper and pencil	11
Yavalath	13
Pentalath	15
Yavalanchor	17
Yavalade	19
Cross	21
Omega	23
Manalath	25
Odd	27
Coffee	29
Games with stone movement	33
Feed the Ducks	35
Susan	39
Taacoca	41
Quantum Leap	43
Play Win	45
A game with stacking mechanism	49
Onager	51

The Yavalath set

Prologue by Cameron Browne

Yavalath is a board game with extremely simple rules, but an emergent twist that makes it interesting and fun to play. It came about as a result of the following question: *can computers invent board games?*

This question inspired me to embark on a Ph.D. project in which I stripped a number of known games down to their component rules, wrote a language to encode these rules, and developed a program called LUDI to evolve rule sets into new configurations using an evolutionary approach. Yavalath was the most popular game evolved by LUDI, and has gone on to become more popular than any game that I have invented myself, at one point being ranked in the top #100 abstract board games of all time (www.boardgamegeek.com). So the answer is: *yes, computers can invent board games!*

Yavalath is interesting because its "win with N but lose with $N-1$" rule allows players to make unexpectedly complex traps through chains of forced moves. It is fun to play because the rules are so intuitive -- everybody is familiar with N-in-a-row games – but provide an "aha!" moment when players first discover the forced move mechanism for themselves, then want to explore this mechanism further in game after game.

The hex hex board (a hexagon tessellated by hexagons) is the ideal surface for playing Yavalath. Apart from its sheer elegance and aesthetic beauty, it has the right geometric qualities; a square grid would make the game too hard to win without diagonals and too easy to win with diagonals. The hexagonal tiling eliminates the distinction between orthogonal and diagonal neighbours altogether, and allows players to make specific threeway threats that manifest as triangular patterns. It is natural to wonder what other games might be played on this beautiful board.

<div style="text-align:right">
Cameron Browne

June 2014

Brisbane
</div>

The set

This book features 15 games that can be played with a Yavalath set, including Yavalath itself. A Yavalath set includes a hexagonal board of 5 hexes per side, 30 black stones, 30 white stones and at least 25 red stones.

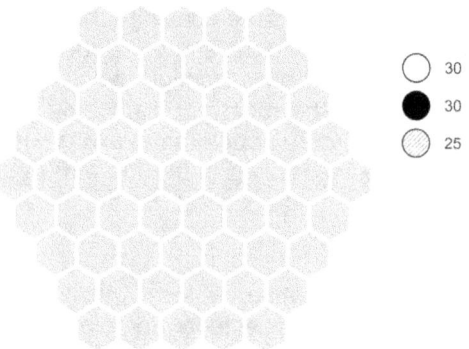

Some of the games included in this book were designed before Yavalath was invented, some have been designed exclusively for this set and others have been adapted to it. Moreover, some of the games can be played with paper and pencil (you can print the board above).

Grab some friends and a Yavalath set, and have some fun!

The games

Games playable with paper and pencil

Yavalath

LUDI (2007)

*Yavalath is an abstract board game for two or three players, invented by a computer program called **LUDI**. It has an easy rule set that any player can pick up immediately, but which produces surprisingly tricky emergent play.*

*Yavalath is available from **nestor**games, making it the first — and still only — computer-generated game to be commercially published, together with its sister game Pentalath.*

*In October 2011, **Yavalath** was ranked in the top #100 abstract board games ever invented on the BoardGameGeek database. This helped it win the GECCO "Humies" gold medal for human-competitive results in evolutionary computation for 2012.*

GAME RULES

The game begins with an empty board.

Each player has an allocated colour: *White* or *Black*.

Starting with *White*, players take turns placing a *stone* of their colour in any empty cell on the board.

On his first move, *Black* may elect to swap colours (swap option). This is to stop overly strong opening moves.

END OF GAME

The game ends in one of the following cases:

 a) One of the players **wins** a game by making a line of four (or more) *stones* of his colour.

 b) One of the players **loses** a game by making a line of three *stones* of his colour without making a line of four *stones* the same time.

 c) The board fills up before either player wins or loses. In this case the game ends up in a **draw**.

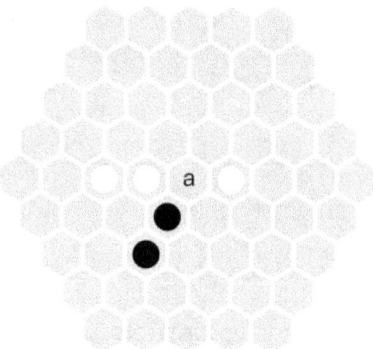

Example: 'a' is a winning move for white, but a losing move for black.

3 PLAYER VARIANT

This variant is played according to the same rules, except that players must block the next player's win if possible, and any player forming a line of three *stones* without also forming a line of four *stones* is removed from the game (but not their *stones*). The winner is either the last surviving player or the first player who forms a line of four *stones*. (the 3rd player uses the red counters)

Pentalath

LUDI (2007) 2-2 2 15

Pentalath is a 5-in-a-row game initially designed by LUDI to be played on an unusual trapezoidal board, using Go capture rules. Of the 19 games that Ludi invented, this was the game most preferred by both Ludi and human testers. It was originally called **Ndengrod** but was renamed to **Pentalath**, to highlight its relationship to sister game **Yavalath**. It can be played on Yavalath's hexagonal board although I strongly recommend the original trapezoidal board, which is is available from **nestor**games.

GAME RULES

The board starts empty. White plays first.

Players take turns placing a piece of their colour on an empty cell. Passing is not allowed.

After each move, enemy pieces with no *freedom* are captured and removed from the board. A piece has freedom if the group it belongs to touches an empty cell.

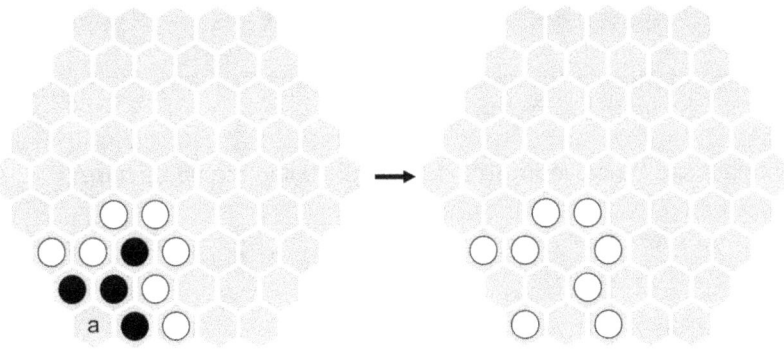

Example: the black group below has one freedom marked 'a'. If White plays there, then the black group has no remaining freedoms and is captured.

No suicide: It is not allowed to place a piece in a space without freedom, unless that move captures enemy pieces to create freedom.

Move 'a' (above) shows an example of a move capturing enemy pieces to create its own freedom. The white piece is totally surrounded when played, but it captures the black group to clear space around it as part of the move.

END OF GAME

The game ends when one of the players **wins** a game by making a line of **five** (or more) *stones* of his colour.

NOTES

There is no *ko* rule (a special rule required in Go to avoid repetitions) as the hexagonal grid avoids *ko* cycles. This is because there are no diagonals on the hexagonal grid.

It is more difficult to capture pieces than in Go, as each cell has six potential escape routes rather than four. However, the "no pass" rule means that freedoms will eventually fill up and captures will inevitably occur. The "no suicide" rule stops players burning unwanted moves, to guarantee that this happens.

The main strategy is to isolate enemy groups that are blocking you, in order to remove the blockage.

Pentalath can be played with three colours using the same rules.

Yavalanchor

Néstor Romeral Andrés (2012) 2-2 2 15

Yavalanchor is a *Yavalath* derivative for 2 players that can be played with the same set of components. It features a nice mechanism called 'anchorage', where players are forced to play their pieces next to others previously played called 'anchors'.

GAME RULES

Each player has an allocated colour (White and Black). Red counters are neutral and will act as 'anchors'.

Starting with White players take turns placing either:

 a) a red counter in ANY empty cell or...

 b) a counter of their colour in an empty cell adjacent to a red counter.

...until the victory condition is reached.

GAME END

The game ends when a 5-in-a-row containing only counters of a player colour **and** red is created. The owner of that colour is the winner.

In the rare case of several lines being created, the player that placed the last counter chooses the winning line.

If the board fills up before reaching this victory condition the game ends in a draw.

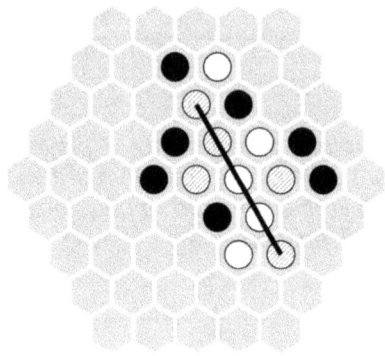

Example: White wins (3 red + 2 white)

Yavalade

Néstor Romeral Andrés (2012) 3-3 ⚙ 2 ⏲ 15

Yavalade is a ***Yavalath*** derivative for 3 players inspired by the game ***Gute Nachbarn***.

SETUP

Each player has an allocated colour (White, Black, Red).

The playing order is White-Black-Red.

White player takes a red piece and places a white piece on top of it, placing the stack before him.

Black player takes a white piece and places a black piece on top of it, placing the stack before him.

Red player takes a black piece and places a red piece on top of it, placing the stack before him.

HOW TO PLAY

Starting with White, players take turns placing a piece of their colour on an empty space of the board until the victory condition is reached.

GAME END

The aim of the game is to create a 5-in-a-row containing both and only both colours of your stack.

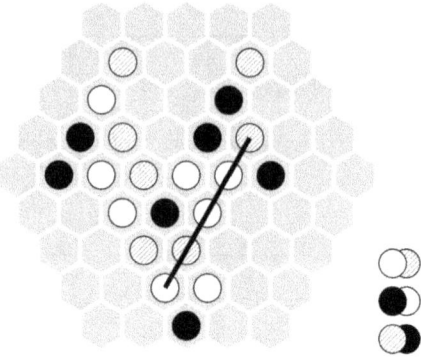

Example: White wins with a 5-in-a-row containing white **and** red pieces.

NOTES

If a longer row or more than one row are created, the player that placed the last piece chooses the winning row.

STRATEGY

As a rule of the thumb, Black must block White that must block Red that must block Black.

Cross

Cameron Browne (2011) 2-2 ⚙ 2 ⏱ 15

*In **Cross**, a player wins by connecting three non-adjacent board sides with a chain of their pieces. But a player loses by connecting two opposite board sides with a chain of their pieces (without also connecting three non-adjacent sides).*

***Cross** is usually played on bigger boards (available from **nestor**games), but the **Yavalath** set is perfect for beginners.*

HOW TO PLAY

Starting with White, players take turns placing a *stone* of their colour in any empty cell on the board.

On his first move, Black may elect to swap colours (swap option).

END OF GAME

The game ends in one of the following cases:

a) A player **wins** a game by connecting three non-adjacent board sides with a chain of their pieces.

b) A player **loses** a game by connecting two opposite board sides with a chain of their pieces (without also connecting three nonadjacent sides).

Each corner cell belongs to both sides that meet there.

Example: Black wins

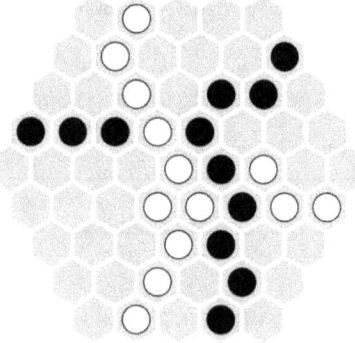

Example: White loses

Omega

Néstor Romeral Andrés (2010)

Omega *was born as an experiment on complexity and intuitive arithmetic. Both concepts teamed up to create this little monster. It feels like a cross between Hex and Go.*

*In **Omega**, players try to create groups of their colours by placing stones in a hexagonal grid, in order to score the most points. But each player places stones of all colours in play. The final score for each colour is calculated by multiplying the sizes of the different groups of that colour.*

You will soon realize that you don't need to calculate your score during play (multiplying your group values). Use an intuitive strategy instead. How? You must figure it out by yourself.

Omega *can be played with up to 4 players and on bigger boards with the official set from **nestor**games.*

HOW TO PLAY

Each player has an allocated colour.

Starting with White, players take turns in order.

Each turn, the current player **must** place **one stone of each colour in play** on any free spaces on the board. This is, for a 2-player game, the player in turn places one white stone and one black stone; and for a 3-player game, she places one white stone, one black stone and one red stone.

On his first move, Black (and Red in a 3 player game) may elect to swap colours (swap option).

END OF GAME

The game ends when, just **before White's turn**, it is not possible to play a complete **round** (all players). For a 2-player game, at least 4 free spaces are needed to play a complete round; and 9 for a 3-player game. A few spaces will remain free at the end of the game.

Several groups of connected stones of the same colour have been created. The 'value' of a group is the number of stones on that group. To calculate your score **multiply** the values of all the groups of your colour. The player with the highest score wins. In case of a tie, the last of the tied players wins.

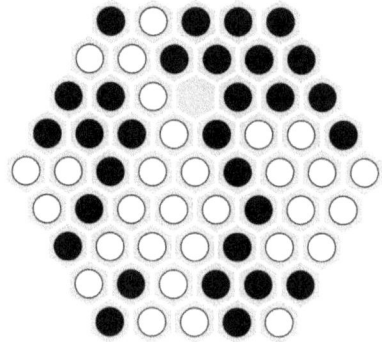

Example:
White wins with 17 x 9 x 3 = 459 points vs. Black 19 x 8 x 2 = 304 points.

Manalath

Dieter Stein and Néstor Romeral Andrés (2012)

*The precursor of **Manalath** (which was called "Quarti", then "Quinti") was devised by Dieter Stein in 2006 and was first set aside, as the designer was not satisfied with it. Later as Cameron Browne published **Yavalath**, the idea came back to the surface, but still there was no substantial progress.*

*Finally in 2012, when **nestor**games published a fine new **Yavalath** set, this game got its last shove in an online brainstorming session with most valuable input by Néstor Romeral Andrés.*

*Special credits go to **Cameron Browne** for finding the name of the game **Manalath** (from lat. "manus", referring to the five fingers of the hand).*

HOW TO PLAY

The board is initially empty. Players take turns.

In your turn, choose a piece of **any** colour (i.e. a friendly or opponent piece, as long as there are pieces available) and put it on an empty space.

A piece may not be placed such that a group of **more than 5** pieces is created.

END OF GAME

If, **at the end** of your turn, ...

 a) there is a group of **5** of your colour, you **win**

 b) there is a group of **4** of your colour, you **lose**.

If you cannot make a valid move, you lose.

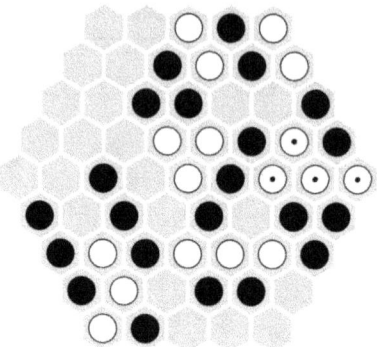

Example: It's White's turn. White cannot legally grow the group of 4, so at the end of her turn, she will lose the game.

Odd

Nick Bentley (2007) 2-2 1 30

Odd *is a two-player abstract board game with asymmetrical goals, where one player tries to create an odd number of groups, while the other tries to avoid it.*

GAME RULES

The board begins empty. The players share a common pool of White and Black stones.

Two players (*Odd* and *Even*) take turns. *Odd* starts. On each turn a player places one stone of **either** colour onto any empty space.

GAME END

The game ends when the board is full. Player *Odd* wins if there is an odd number of groups of at least size 5 on the board, and Player Even wins otherwise. When counting groups, be sure add up the total number of connected groups of both colours.

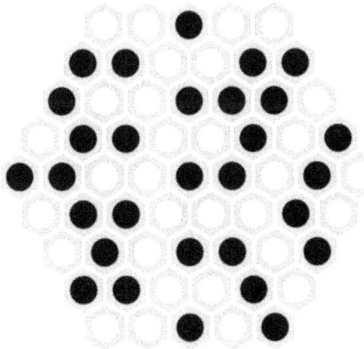

Endgame example. Odd wins as there are 3 groups of size 5 or more.

Coffee

Néstor Romeral Andrés (2011)

Coffee is a two-player abstract board game can be played on any hexagonal or square board. The goal of the game is to create a line of stones of your colour, or to prevent your opponent from making a legal placement.

You will need a small rod of the same size as the **Yavalath** stones.

When placing the rod on a black stone, it looks like a coffee seed. Hence the name of the game.

GAME RULES

Determine the winning condition 'n' (number of stones in a row). 'n' cannot be larger than the side of the board. For a Yavalath board, I recommend a value of 3 or 4.

The game begins with an empty board.

Each player has an allocated colour: Black or white.

The pie rule may be applied upon agreement (swapping colours after Black's first turn).

Black starts by placing a stone on an empty cell, and then placing the white rod on it, pointing in any of the 3 directions.

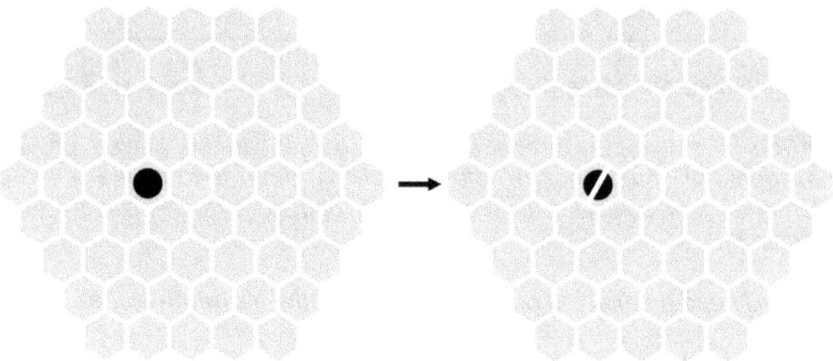

Black places a stone in a n=4 game. Black then places the rod on it, pointing in any of the 3 directions

From now on, starting with White, players alternate turns first placing a stone on an empty cell in the direction indicated by the rod, and then placing the rod on it, pointing in any of the 3 directions.

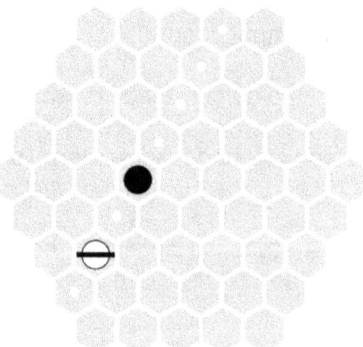

White places a stone on an empty cell in the direction indicated by the rod (other legal moves indicated in white) and then places the rod on it, pointing in any of the 3 directions

It is **illegal** to place the rod so that the next player has no **free spaces** available.

GAME END

The game ends in one of the following cases:

a) One player **wins** the game by making a 'n-in-a-row' of his colour (with 'n' being the victory condition).

b) One player **loses** the game because he cannot place the rod in a legal position.

In case of both cases happening on the same turn, the first case prevails.

Notice that ties are not possible.

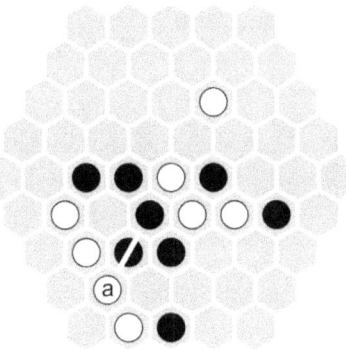

Example: White wins by placing a stone in 'a'

Games with stone movement

Feed the ducks

Néstor Romeral Andrés (2011)

Néstor and his daughter sit next to a small duck pond, tossing breadcrumbs into the water. With each ripple from a crumb, ducks race toward the new treat. (They never actually get the snack, due to the wily fish just below the surface, but it doesn't dissuade them from trying!) Passersby watch the scene for a moment, then smile, charmed by these people idling away their time. Little do they realize that these crafty individuals actually have a standing wager: Each has chosen a colour of duck in the pond as his own, and whoever can gather his ducks into a group first gets to choose the adventure for the day!

Feed the ducks is a game originally designed for 2 to 4 players that can be played by two players with a Yavalath set. Players drop breadcrumbs into the pond, in order to attract the ducks. The first player to coerce all the ducks of his colour into a single group wins.

You will need a breadcrumb to play the game (you can use a red stone instead, but ducks don't like red stones much).

*You can get the 2-4 player set from **nestor**games.*

SETUP

Each player has an allocated colour (Black or White).

To set up the pond, fill the outer edge of the pond (one duck per space): Starting with White, players take turns counterclockwise placing any duck on an edge space of the pond.

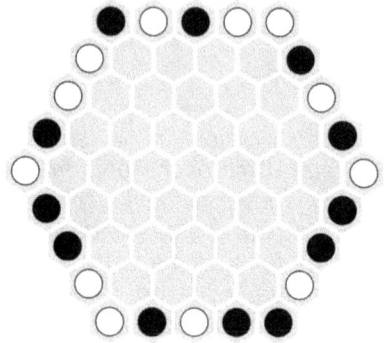

Example of setup

Take a breadcrumb and place it next to the board.

The game can start now. White plays first.

PLAY

The game is played in turns. White starts by placing the breadcrumb on any empty space on the board.

Now, **any and every** duck in the six lines radiating out from the breadcrumb move straight toward the breadcrumb as far as they can. There will never be more than one duck in a space, and the ducks stop just before they reach the breadcrumb (a fish gets it first).

Then the turn passes to the next player.

From now on, on your turn, you **must** take the breadcrumb and place it on an empty space of the board that is **not** on any of the six lines radiating from the breadcrumb's previous location and then move the ducks toward the breadcrumb as usual.

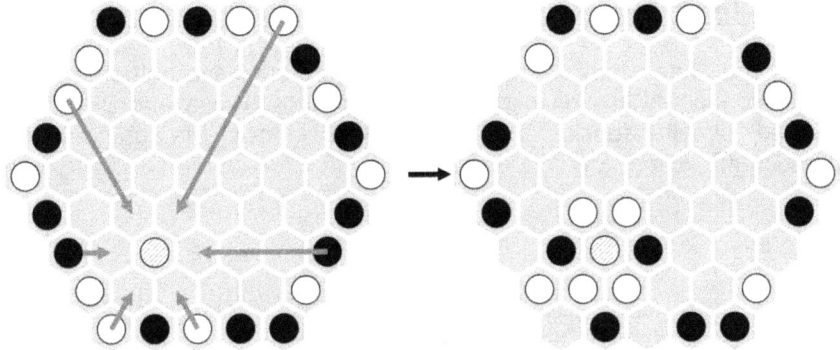

Example: White places the breadcrumb and the ducks move towards it.

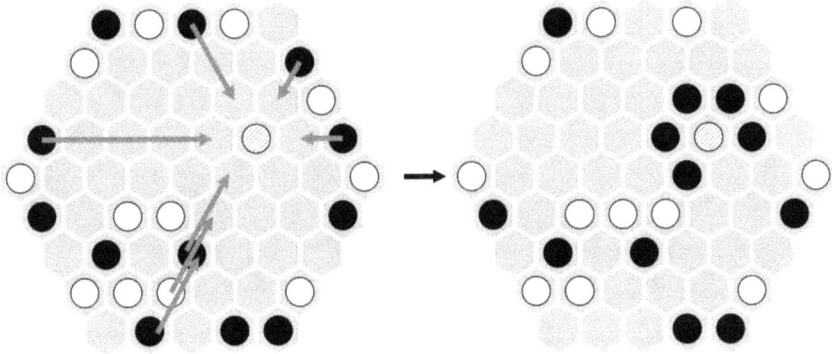

Then Black places the breadcrumb on an empty space on the board that is not on any of the six lines radiating from the breadcrumb's previous location. Finally all ducks in the six lines radiating from it move toward the breadcrumb.

GAME END

The game ends when all the ducks of one colour have gathered into a single connected group. In case of both groups (White and Black) are created simultaneously, the player who placed the game-ending breadcrumb wins.

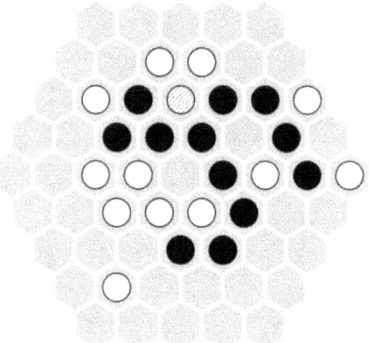

Example of a game won by Black

Susan

Stephen Linhart (1991) 2-2 2 15

Susan *is a game reminiscent of go that adds a stone movement mechanism.*

Susan *was the name of the waitress of the café where one day the designer was showing the game to a friend.*

HOW TO PLAY

Each player has an allocated colour.

Players alternate turns until the victory condition is reached. A player's turn consists on either

- a) placing an off-board stone of their colour on an empty field on board, or

- b) sliding an on-board stone of their colour onto an adjacent empty field.

You cannot pass. If each player is performing three slides in a row (meaning six consecutive plies or game actions being slides in total) then the game ends immediately as a draw.

END OF GAME

You win as soon as any of the opponent's stones is surrounded on all liberties. Surrounding this stone is valid by any combination of own stones, opponent's stones, and even the board edges.

If one of your own pieces is surrounded on your turn, you lose even if an opponent's stone is surrounded at the same time.

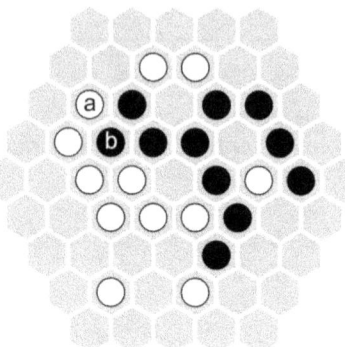

Example: White wins playing 'a', fully surrounding 'b'.

Taacoca

Víkingur Fjalar Eiríksson (2009) 👥 2-2 ⚙ 2 ⏱ 30

*The objective of **Taacoca** is to reach the opponent's Home row with one of the player's stones.*

HOW TO PLAY

The bottom row is the *Home* row for the *White* player. The top row is the *Home* row for the *Black* player.

Initially each player has 12 *stones* of his colour. The initial position of *stones* is shown on the following picture:

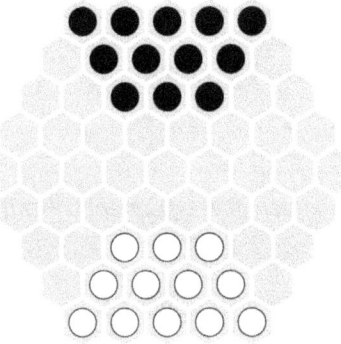

Starting with *White*, players take turns moving any three of their *stones* one cell forward (if a player has less than three *stones* he must move all the remaining *stones*, if that's not possible, he loses the game). The chosen *stones* do not need to be connected to each other but they must move in the **same direction**:

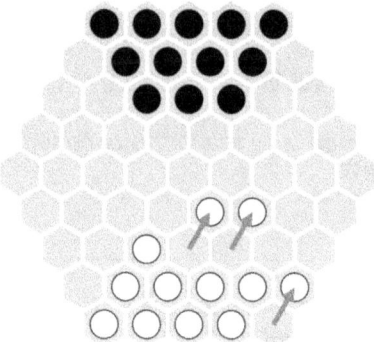

Example of movement

A player cannot move his *stones* if one of the target cells is occupied with another stone **of the player**. If some of the target cells (or all of them) are occupied with **opponent's stones** then the opponent's stones are captured and removed from the board.

END OF GAME

The objective of is to reach the opponent's *Home* row with one of the player's stones.

A player also wins a game if the opponent is left without any *stones or without any moves*.

No draws are possible in *Taacoca*.

Quantum leap

Néstor Romeral Andrés (2013) 2-2 3 30

Quantum Leap *is a board game for 2 players than can be played on a hexagonal grid of any shape and size. The official rules use a hexagonal board of 5 hexes per side, 30 white stones and 30 black stones, as it is the recommended configuration for beginners.*

In ***Quantum Leap****, each player's stones start dispersed on the board. Your goal is to be the last player making a valid move. Stones can only move by capturing enemy stones, leaping in a special fashion. Stones get their leaping potential from the number of friendly stones that immediately surround them.*

Special thanks to Cameron Browne for the game name.

HOW TO PLAY

Randomly distribute the supply of stones (30 of each colour) on the board cells (61), so each cell contains only one stone and there is one free space left. This free space can be anywhere except the centre space (to avoid possible but rare symmetries on the board).

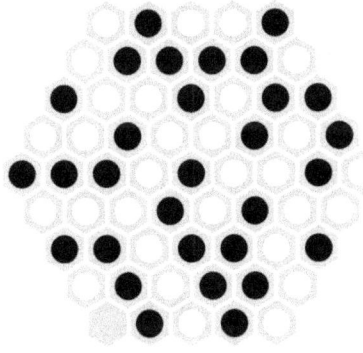

Setup example

Each player has an allocated colour (white or black).

Before the game starts, Black can swap the positions of any two stones on the board.

White the starts the game. Players alternate turns during the game until one of them cannot make a valid move, thereby losing the game.

On your turn, you must make **one** capture. A stone makes a capture by leaping in a straight line in any of the 6 directions exactly as many spaces as friendly stones surround its original position, and landing on an enemy stone, which is removed from the game (the attacking stone occupies its place). Stones can leap over other stones.

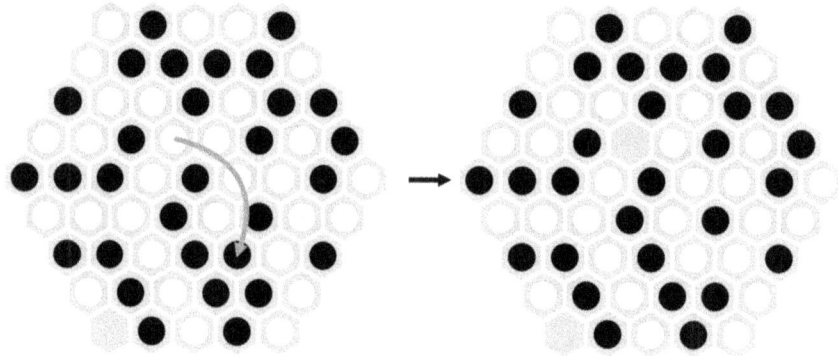

Example of capture. The white stone is surrounded by 3 friendly stones, so it leaps exactly 3 spaces to capture the black stone.

END OF GAME

If you cannot make a capture on your turn, you lose.

STRATEGY TIPS

Isolated stones cannot capture, so try to keep your stones connected in groups of at least 2. For the same reason, try to split enemy groups into smaller groups or isolated stones.

Play Win

Élanor Grace Rodeffer (2011) 👥 2-2 ⚙ 3 🕐 30

Play Win is a predatory game. Move your pieces toward opposing pieces along empty lines up to one fewer cell as you have pieces in play. Maximally capture opposing pieces by a series of short bent leaps. Win by capturing or immobilizing all opposing pieces.

HOW TO PLAY

Place the board between the two players with an edge facing each player. Arrange your eleven pieces on the nearest two rows of cells.

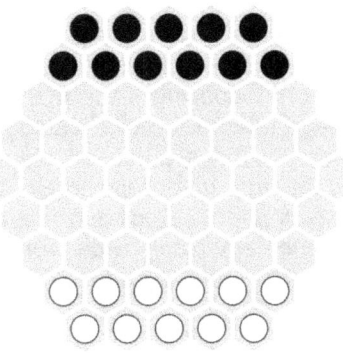

Setup

Decide who will move first.

On your turn, you must capture if possible. If multiple capturing moves are available, choose freely among those that capture the most opposing pieces. Capture by a series of "turny jumps" or short bent leaps, and immediately remove captured pieces. A turny jump moves over an adjacent cell occupied by an opposing piece to an empty cell beyond and 60° to the left or right. You may revisit the same cell more than once as part of a capture series. *The diagram below shows white capturing six black pieces by a series of short bent leaps.*

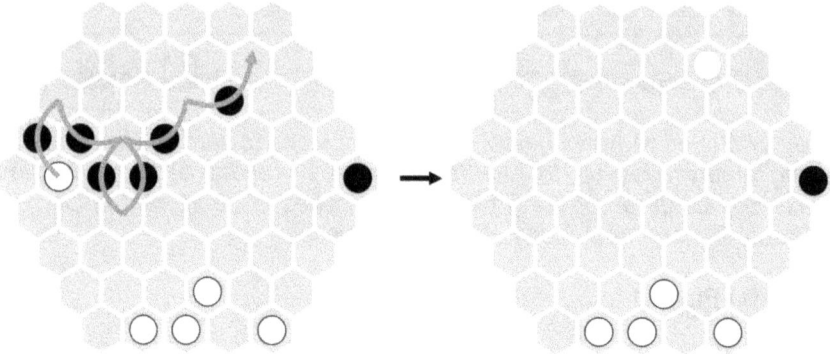

If you have no capturing moves available, approach an opposing piece with your own piece. Move a piece so it stops closer to at least one opposing piece than its original distance to all opposing pieces. (Warmer variant: Until one player is reduced to six pieces, move a piece so it stops no farther from at least one opposing piece than the original distance to its closest opposing piece.) Move the piece along an empty line of cells up to one fewer cell as you have pieces in play. Thus, a single piece cannot move without capturing. Immobilization loses. *The diagram below shows possible moves for black. Since there are four black pieces in play, the maximum distance any black piece can move is three cells, and the moved piece must end its move closer to an opposing piece.*

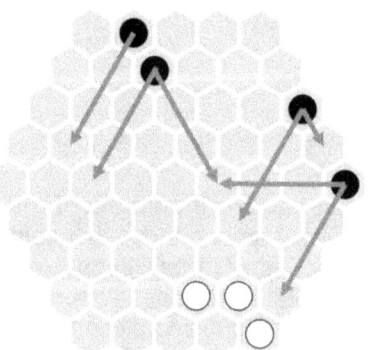

END OF GAME

Win by capturing or immobilizing all of your opponent's pieces.

A game with stacking mechanism

Onager

Néstor Romeral Andrés (2012)

Onager *is an abstract game in which each player tries to reach the opponent's back rank.* **Onager** *is named after a Roman siege engine that is a type of catapult, as the way the pieces move resembles how projectiles are hurled forward with this device.*

Onager *was inspired by the game* **Epaminondas**, *a masterpiece designed in 1975 by Robert Abbott, and also published by* **nestor**games. **Onager** *uses simple mechanics with a classy feeling similar to those in Chinese Checkers, Halma, or Bashni.*

Onager *is played on a bigger board of 6 hexes per side, but a smaller version of it can be played with the Yavalath set.*

PREPARATION

Each player has an allocated colour (*Black* or *White*).

Fill your 2 nearest rows with discs of your colour (one per cell).

Then, starting with *Black*, players alternate turns placing one 'lake' (red stone) on any empty space of the board *except the centre space* (so Black places 2 lakes and White places 1). The lakes are used to prevent symmetric play and to create a different landscape for each game.

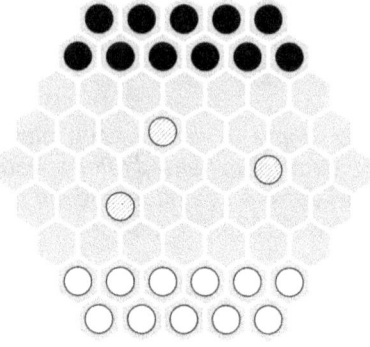

Setup example

CONCEPTS

Pieces

From now on, we shall use the term '*piece*' to refer either to an isolated disc (not part of a stack) or the topmost disc of a stack. Discs that are part of a stack but are not the topmost one are not considered *pieces* (until they are 'liberated' by moving away the disc on top of them).

Stacks

Whenever a *piece* jumps on top of an **enemy** *piece* a *stack* is created. Higher stacks can be created as a result of jumps. Only the topmost disc can move from a stack (because it is a piece), therefore liberating the disc underneath (which then becomes a piece).

The height of a stack is irrelevant.

HOW TO PLAY

Black starts. Players alternate turns during the game until the victory condition is reached.

On your turn, **either** *walk* **or** *jump* with **one** of your *pieces*.

Walk

Move **one** of your pieces to an adjacent **empty** space.

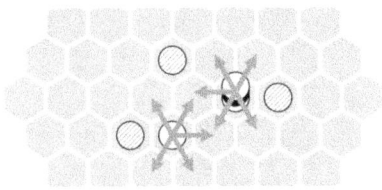

Examples of valid walks for White.
Remember that only the topmost disc of a stack can be moved.

Jump

In order to jump, 2 friendly pieces must be aligned in any of the 3 directions with no obstacles (lakes or other pieces) between them. Both pieces can be adjacent or separated by spaces.

One of the pieces then jumps in that direction over the other piece, landing on a space beyond that is at a distance equal to the distance between the two friendly pieces before the jump was made (like a mirror).

The landing space must be either empty or occupied by an enemy piece. A piece cannot land on a lake or a friendly piece. Pieces cannot land outside the board.

Notice that the spaces between the piece jumped over and the landing space don't need to be empty. If the jumping piece lands on top of an enemy piece, it creates (or enlarges) a stack of discs (see 'Stacks'). Enemy pieces are neither captured nor removed from the game.

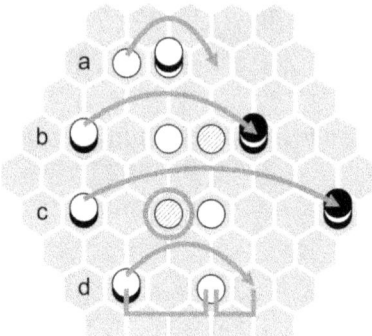

Examples of legal and illegal jumps:
a) Legal: Landing space is empty. Same distance.
b) Legal: Spaces between jumping and jumped-over pieces are empty. Same distance. Destination occupied by enemy piece.
c) Illegal: Obstacle between jumping and jumped-over pieces.
d) Illegal: Not same distance.

Multiple jumps: If, as a result of a jump, a piece lands **on top of an opponent's piece**, it can make another jump movement (under the same conditions), and so on. This is not mandatory.

You **cannot** combine walks and jumps.

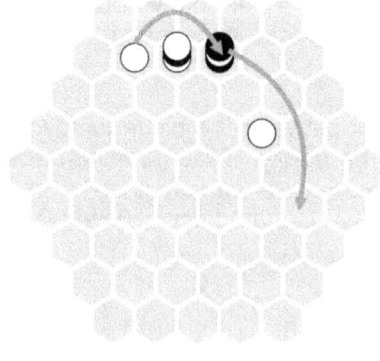

Example of multiple jumps

GAME END

If at the **start of your turn** you have more pieces on your opponent's back rank than your opponent has on your back rank, then you have won. *Remember the definition of 'piece'.*

If the above condition is not reached and you can't make a legal movement at the start of your turn, you lose. This rarely happens. Players may agree on a draw at any moment during the game.

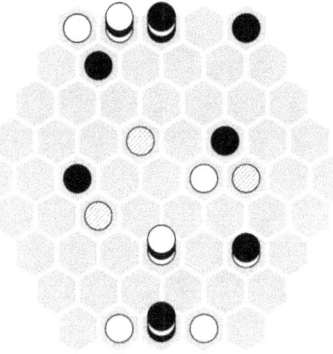

Endgame example:

White's turn. White wins by having more pieces on Black's back rank (bottom) than black pieces on White's back rank (top): 2 to 1.

STRATEGY TIPS

Don't read this if you wish to discover the game by yourself!

a) Pieces can jump from large distances, and even cross the entire board in a single jump!

b) You can block a threatening jump by simply placing a piece between the two enemy pieces.

c) Try to threaten several pieces with the same move.

d) Try to control the centre space of the board.

e) Having discs trapped in stacks is not that bad, because you're still threatening to move if they're liberated.

f) Because your back rank can be reached by either walking or jumping, but only defended by jumping, purely defensive play is not a good strategy (not enough pieces to defend it). You must balance defensive and offensive play.